D0438377

# Painting
# Waterscapes

## A POCKET REFERENCE

Practical visual advice on
how to create waterscapes
using watercolors

Joe Francis Dowden

BARRON'S

A QUARTO BOOK

# COLORS USED IN THIS BOOK

All inquiries to be addressed to:
Barron's Educational Series, Inc.
250 Wireless Boulevard
Hauppauge, NY 11788
http://www.barronseduc.com

Library of Congress Catalog
Card Number 2002107355

ISBN 0-7641-5614-4

9 8 7 6 5 4 3 2 1

Naples yellow ***O

yellow ochre ****O

raw sienna ****Tr G

cadmium orange ***O

translucent orange***Tr St

cadmium scarlet***O St

alizarin crimson*Tr St

burnt sienna ****Tr

light red ****O

sepia ****O

Payne's gray ***O St

neutral tint ***O G St

cerulean blue ****O G

phthalo blue ***Tr St

French ultramarine ***Tr G

## CODES

| | | | | |
|---|---|---|---|---|
| **** | Extremely permanent | | G | Granulating color |
| *** | Permanent | | O | Semi-opaque/opaque |
| ** | Moderately durable | | Tr | Semi-transparent/ transparent |
| * | Fugitive color | | St | Staining color |

# CONTENTS

new gamboge
***Tr

cadmium lemon
***O

cadmium red
***O G

quinacridone
red***T

Indian red
****O

burnt umber
****O

indigo
***O St

cobalt blue
****Tr

cobalt
turquoise****O

phthalo green
****Tr St

titanium white
****O

# HOW TO USE THIS BOOK

THIS BOOK IS intended as a starting point for your explorations of waterscapes. Use it both as a practical guide to tips and techniques for painting waterscapes and as a source of ideas. Compact and easily portable, it is the perfect reference guide to take with you when you are painting on location.

The book begins with an introduction to the basics of painting in watercolor, with particular reference to ways of painting water. Then you will find 50 projects, covering the whole array of waterscapes from rocks in a small stream to crashing surf in open seascapes. Whatever kind of water you are painting, in whatever type of landscape or light, use these pages for quick-and-easy reference. Each project is explained step-by-step so that you can see how the painting is built up and contains a full list of the colors used. Work through them at your leisure, or simply dip into them as you choose to master particular aspects of painting waterscapes.

*Direction is given in the introduction on techniques relevant both to general watercolor painting and specifically to painting waterscapes.*

*Projects are divided into broad subsections, which can be seen at a glance across the top of each page.*

*The colors required for each painting are set out along the top of the page, so exactly what is needed is clear.*

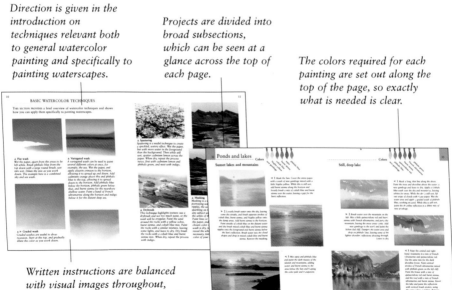

*Written instructions are balanced with visual images throughout, making the book ideal to use both as a quick reference or as a more detailed guide.*

*Each waterscape is painted as a sequence of one or two steps, followed by a final painting. Captions describe the colors used, the color mixes required, and the techniques involved.*

# INTRODUCTION

THIS BOOK DEMONSTRATES how to paint waterscapes—that is, water in its surroundings, from river, brook, or garden pond to boat-filled harbor or ocean surf.

Everyone loves paintings of water, but capturing water on paper can be quite a challenge. Water is completely colorless: it takes its appearance from what is around it and from the prevailing weather and lighting conditions. A tranquil river on a calm day literally mirrors its peaceful setting with the bright sunshine piercing the woodland canopy. On a windy day in the same location, wind might scuff the surface of water like sandpaper. A fast-flowing river or waterfall will throw out spray that glistens and sparkles in the sunlight.

Although the term waterscapes covers a tremendous variety of scenes, there are a number of very simple techniques that you can use to paint water convincingly. This book aims to provide you with a repertoire of skills that you can build on and develop in your own work.

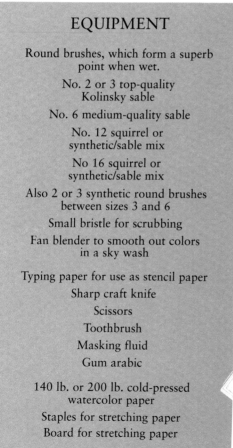

## EQUIPMENT

Round brushes, which form a superb point when wet.

No. 2 or 3 top-quality Kolinsky sable

No. 6 medium-quality sable

No. 12 squirrel or synthetic/sable mix

No 16 squirrel or synthetic/sable mix

Also 2 or 3 synthetic round brushes between sizes 3 and 6

Small bristle for scrubbing

Fan blender to smooth out colors in a sky wash

Typing paper for use as stencil paper

Sharp craft knife

Scissors

Toothbrush

Masking fluid

Gum arabic

140 lb. or 200 lb. cold-pressed watercolor paper

Staples for stretching paper

Board for stretching paper

# LOOKING AT WATERSCAPES

EVEN THE MOST mundane subjects can be beautiful if you visualize them in the right way. Here are a few simple guidelines that will help you to make your waterscapes more interesting.
• Decide on the shape, or format, of the image before you start painting. Make rough sketches before you start painting to decide what best suits your subject.

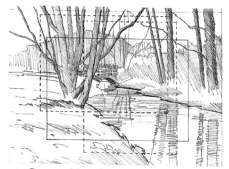

▲ Compositional decisions
*Dotted lines show possible shapes to create the image size and format.*

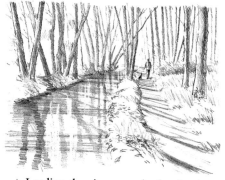

▲ Leading the viewer to the focal point
*The river here leads the viewer through the image to the point where the figure is walking along the bank.*

• Try not to divide the picture into two equal halves by placing the horizon, or the main point of interest, in the very center of the picture. Offsetting them makes for a much more dynamic image.
• Lead the viewer through the picture to the main point of interest: include a winding path or river leading to the focal point, or place important features on an implied diagonal line.
• Look for contrasts of tone in your subject to bring out the shape and form. Balance light areas with darker tones. Make a simple tonal sketch before you start painting to plan where the light and dark areas are going to be.

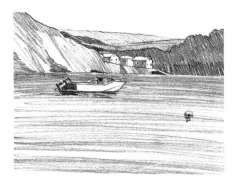

◄ Tonal variation
*Organizing and juxtaposing the lightest and darkest tones in a painting gives depth to a composition, as shown here by the dark cliffs next to the bright houses and sunlit hillside.*

• Make a note of where the light is coming from when you start painting. The direction of light changes during the day. If you do not do this, you may find that you inadvertently paint shadows that fall in different directions. Light pencil arrows on the side of the paper are all you need as a reminder.

• Remember the rules of perspective. Any image painted on a horizontal plane will have the horizon as its vanishing point—and the vanishing point in any scene is roughly at your eye level. You may not actually be able to see the horizon (in dense woodlands, for example), but you can always work out where it is and plot it in your image. Construct faint pencil lines back to converge on a horizon line; this will help you to ensure that the key elements in your painting are the right size in relation to each other.

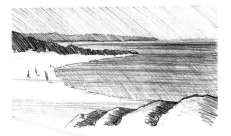

▲ **Light direction**
*Here, the Sun's direction is from the left. This is shown by the left sides of the rocks catching the light as well as the shadows of the figures on the beach.*

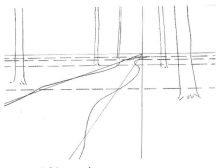

▲ **Vanishing point**
*All parallel lines will meet at a vanishing point on the horizon, which helps to position and size the respective elements to be drawn.*

• If the scene is very cluttered and busy (a harbor scene, for example), simplify it by removing elements.

• Paint elements in the foreground and middle ground in more detail than those in the background. This not only simplifies the image and eliminates potentially distracting elements, but it also helps to give an impression of depth and distance.

▲ **Creating depth and distance**
*Here the detail of the boat is brought forwards by the more sketchy impression of the houses receding into the distance.*

# COLOR

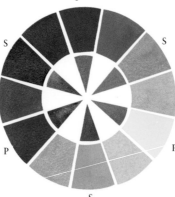

THE EYE PERCEIVES thousands of colors. All of these are mixed from a combination of the three primary colors—red, yellow, and blue. These cannot be mixed from any other color, although slightly different hues such as alizarin crimson, cadmium red, French ultramarine, phthalo blue, cadmium lemon, and new gamboge can be obtained for watercolor purposes. Any two primary colors mixed in equal quantity will produce a secondary color—orange, violet, or green. The secondary colors are positioned on the wheel between the primaries from which they are derived.

A secondary mixed with a primary in equal measure gives a tertiary color, such as apple green or blue green. Tertiary colors can be used harmoniuosly to link the secondary colors to the primary colors to which they relate.

Each color on the wheel is located opposite its complementary color, or the one which provides it with the greatest contrast. Complementary colors juxtaposed within the same painting stimulate the eye, and provide an exciting color scheme. When mixed in equal quantities they give muted colors, or neutrals, as shown in the color wheel below.

▲ **Three-color wheel**
*Equidistant primary colors—alizarin crimson, cadmium lemon, and French ultramarine—form a basic color wheel.*

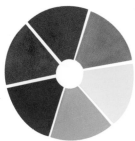

▲ **Six-color wheel**
*The gaps between the primary colors contain the secondary colors mixed equally from their two neighbors. The wheel now provides complementaries opposite every color.*

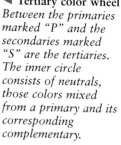

◀ **Tertiary color wheel**
*Between the primaries marked "P" and the secondaries marked "S" are the tertiaries. The inner circle consists of neutrals, those colors mixed from a primary and its corresponding complementary.*

9

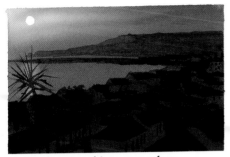

▲ **Image painted in warm colors**
*This image is based entirely on a single wash mixed from cadmium orange, burnt sienna, and quinacridone red. The warm dark of the roofs is balanced by a cool shadow wash.*

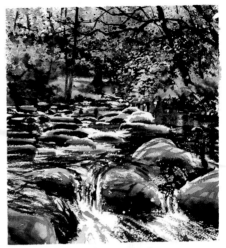

▲ **Image painted in cool colors**
*Initially glazed with cadmium lemon, this image has glazes spattered with phthalo green and indigo. The rocks are painted with a slightly warm gray. Phthalo blue is brushed into the water. The cool darks balance the strong light, and weave the painting together.*

Mixing three primary colors will produce a range of browns and grays, which carry tremendous scope for watercolor painting. Wonderfully subtle effects can be obtained with different mixes. Burnt sienna, for example, is a transparent orange brown, one of the many earth colors. It can be used for evening skies and it makes beautiful grays when mixed with cobalt blue or French ultramarine.

Some artists use just three primaries in their work. Painting with a restricted range of colors means that your painting will be harmonious, as the colors will relate to each other, allowing you to concentrate on other aspects. Use the colors listed in this book to obtain the results shown, or try your own mixes and variations.

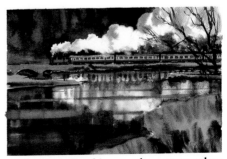

▲ **Image painted in complementary colors**
*Bright greens emerge from the intense gray green backdrop, and energize the red body of the train. The French ultramarine in the vapor trail is balanced by a yellow ochre.*

# BASIC WATERCOLOR TECHNIQUES

THIS SECTION PROVIDES a brief overview of watercolor techniques and shows how you can apply them specifically to painting waterscapes.

▲ **Flat wash**
*Wet the paper, apart from the areas to be left white. Brush phthalo blue from the top down with a large round brush, wet into wet. Dilute the mix as you work down. The example here is a combined sky and sea wash.*

▲ **Variegated wash**
*A variegated wash can be used to paint several different colors at once, for example, the sea. Wet the paper, and apply alizarin crimson to the horizon, allowing it to spread up and down. Add cadmium orange above this and phthalo blue to the top, allowing it to spread down to the horizon. Add phthalo blue below the horizon, phthalo green below that, and burnt sienna for the nearshore shallow water. Paint a band of French ultramarine along the horizon and indigo below it for the distant deep sea.*

▲ ▶ **Graded wash**
*Graded washes are useful to show recession. Start at the top, and gradually dilute the color as you work down.*

**▲ Spattering**
*Spattering is a useful technique to create a speckled, watery effect. Wet the paper, but with more water in the foreground than the background. Then while still wet, spatter cadmium lemon across the paper. When dry, repeat the process twice, first with cadmium lemon and phthalo green, and next with indigo.*

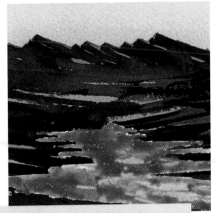

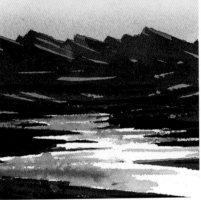

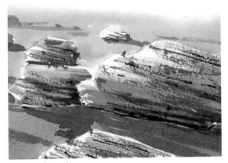

**▲ Drybrush**
*This technique highlights texture: use a drybrush and not too much paint, or the wash will be irregular. Paint the sand around the rocks with a yellow ochre, burnt sienna, and cobalt blue mix. Paint the rocks with a similar mixture, leaving some lights, and leave to dry. Dry brush the rocks with a cobalt blue and burnt sienna mix. When dry, repeat the process with indigo.*

**▲ Masking**
*Masking is a useful technique for portraying water glinting in the distance, ripples, the wake of a boat, and sunshine sparkling on the water surface—indeed, any subject where you want to preserve the white of the paper in the final image. Paint lines or marks of masking fluid on the paper, and allow to dry. Wash your chosen color over the paper. When the wash is dry, rub off the masking fluid to reveal the white paper underneath. If necessary, tint the exposed paper with the color of your choice.*

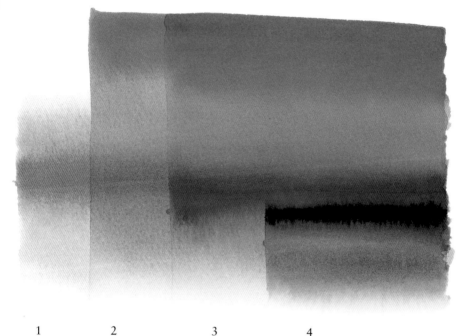

1        2        3        4

## ▲ Sea and sky

*This shows the breakdown of washes in sea and sky. Many other colors can be used besides the ones shown. Here, the paper is divided into four vertical stripes, as labeled. Paint section 1 quinacridone red, wet into a wash of water. Section 2 should be glazed over this in phthalo blue. Add section 3 again in phthalo blue, but with the addition of French ultramarine, wet into wet, along the horizon. For section 4, wet below the horizon only, and add phthalo blue to the water a little below the horizon. Allow it to spread upward to give a faded, distant look to the horizon. While wet, add indigo in the same area, again keeping it below the horizon. Below that paint phthalo green and burnt sienna for the shallow water near the beach.*

## ► Gum arabic

*Gum arabic stabilizes pigment so that it dries into blurred, diffuse lines, making it very useful for wet water effects. Add a few drops of gum arabic to water. Paint Naples yellow and burnt sienna for sunlit mud on the stream bed. While still wet, paint diagonal stripes of Payne's gray for shadows on the river bottom.*

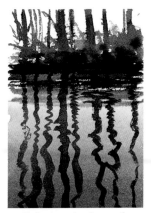

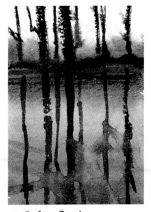

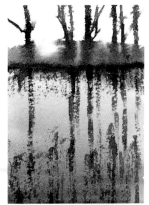

▲ **Painting ripples and reflections**
*Note how the ripples lengthen as they get nearer the observer, demonstrating the perspective of reflections. The ripples in the foreground are larger—as are the bends and twists in the reflections.*

▲ **Soft reflections**
*Brush clean water diagonally back and forth across the foreground using the point of a brush. While this is still wet, paint the reflections, and allow them to diffuse along the wet brush marks.*

▲ **Harsh reflections**
*Use an almost dry brush and just enough water to make the paint workable. This gives a broken texture, as the paint sits on the raised surface of the paper but not in the hollows.*

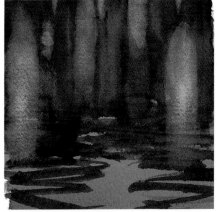

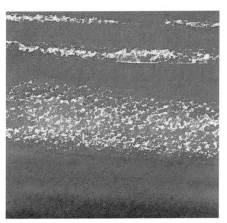

▲ **Lifting out highlights from a reflection**
*Paint the underlying wash, then drag a damp brush downward and dab the area with tissue paper.*

▲ **Painting highlights with candle wax**
*This is a useful technique for creating highlights over water. Simply rub a candle over the area and then brush paint on top.*

# Rivers

## Small river near its source

Colors

cadmium lemon
cobalt blue
burnt sienna
French ultramarine
burnt umber
cadmium red

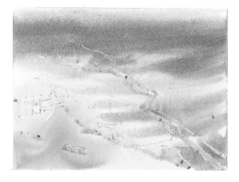

◀ **1** *Mask the river, road, building, fence, people, and rocks. Wet the paper. Paint the foreground and valley floor in cadmium lemon, wash a cobalt blue and burnt sienna mix over the sky, and brush streaks of the same mix across the valley. Brush burnt sienna into the foreground and a mix of French ultramarine and burnt sienna over the distant hills.*

▶ **2** *Rewet the whole image. Brush cadmium lemon and burnt sienna onto the foreground grass. Paint shadows in a French ultramarine and burnt sienna mix. When dry, paint the walls with a burnt umber and French ultramarine mix. With a clean, damp brush, lift paint off the river where the Sun glints on the water.*

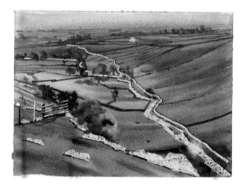

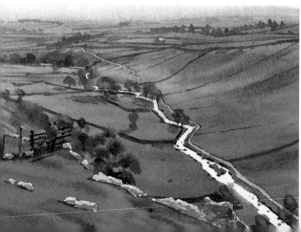

◀ **3** *Add burnt sienna to the edges of the sunlight glint. Remove the masking. Touch the distant river and building with cobalt blue. Paint stones in the river in a mix of burnt umber and French ultramarine. Use a drybrush to paint a cobalt blue and burnt sienna mix onto the foreground rocks. Paint the fence with burnt umber and French ultramarine and the figures with cadmium red and French ultramarine.*

**Colors**

cadmium lemon
cobalt blue
burnt sienna
phthalo green
indigo

# Waterfall

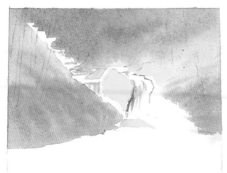

◀ **1** *Mix cadmium lemon, cobalt blue, burnt sienna, and a little phthalo green on the paper, leaving the paper white for the waterfall. Vary the colors on the paper, making them bluer in the distance. Brush a few pale streaks of indigo in the water. Leave to dry.*

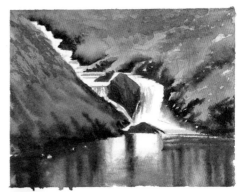

▶ **2** *Deepen the colors on the woodland area, and drop indigo into the shaded edges of the waterfall. Darken the rocks, using the foliage colors plus indigo. Dampen the area below the waterfall, and brush gum arabic onto the paper. Paint this area in cadmium lemon with vertical brush strokes of burnt sienna and indigo, leaving the waterfall reflection white. Leave to dry.*

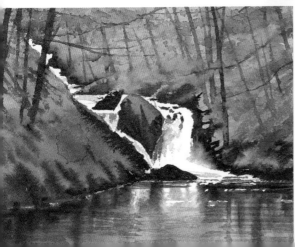

◀ **3** *Paint the smaller rocks in indigo and the trees with an indigo and burnt sienna mix. Paint horizontal ripples spreading from the base of the waterfall with a mix of phthalo green and indigo. Paint hard-edged tree reflections in a phthalo green and indigo mix. When dry, use a knife to lift a few more flashes of white from the water.*

## Shallow river

Colors

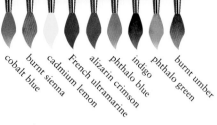

cobalt blue
burnt sienna
cadmium lemon
French ultramarine
alizarin crimson
phthalo blue
indigo
phthalo green
burnt umber

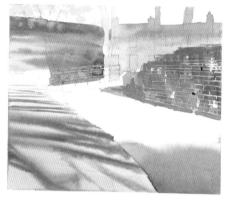

◀ **1** *Mask the bridge rails and masonry paths. Paint the sky a pale cobalt blue and the buildings and wall in grays of cobalt blue and burnt sienna. Paint the leaves and light grass in cadmium lemon. Paint the foreground shadows in French ultramarine and alizarin crimson. Wash a graded phthalo blue and indigo mix on the water.*

▶ **2** *Add indigo accents to the buildings. Mix French ultramarine and cadmium lemon for the grass. Wet the dark reflection area in the water, brush gum arabic onto this part of the paper, and brush vertical strokes of cadmium lemon, burnt sienna, phthalo green, and indigo into the wet area. Brush in the ripples with a mix of French ultramarine and burnt umber.*

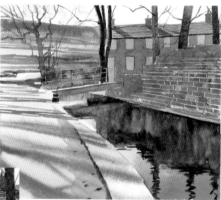

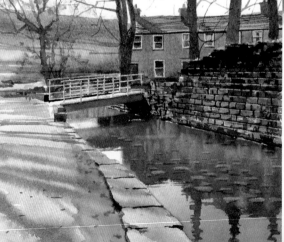

◀ **3** *Paint the darks of the windows, the shadows on the wall, and the area under the bridge in a French ultramarine and burnt umber mix. Use a drybrush to paint the same color on the wall. Paint trees with cobalt blue and burnt sienna. Remove the masking. Paint the wall and bridge with a cobalt blue and burnt sienna mix. Lift highlights off the river with a damp brush.*

## Rocky river

Colors

cadmium lemon
quinacridone red
French ultramarine
burnt sienna
indigo
phthalo green
burnt umber

◀ **1** *Dot masking fluid over the foliage and water. Wash cadmium lemon on the fields. Wet the hill. Wash a quinacridone red and French ultramarine mix on the left side, adding burnt sienna and then quinacridone red to the mix as you move toward the right. Dampen the water area and drop in French ultramarine, burnt sienna, and indigo separately. Leave to dry.*

▶ **2** *Use drybrush streaks of indigo across the river. Dampen the fields and brush in a phthalo green, cadmium lemon, and indigo mix for the shadow areas. Paint the large tree in a French ultramarine and burnt umber mix. Paint shadows on the distant hill in a French ultramarine and quinacridone red mix, and paint the trees on the right in quinacridone red and indigo.*

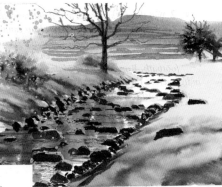

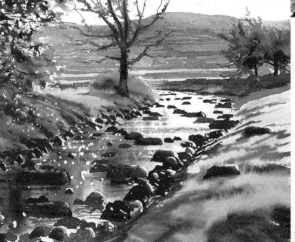

◀ **3** *While the trees are still damp, dab cadmium lemon, phthalo green, and indigo separately on the paper for the foliage. Remove the masking fluid, and touch in some of the white rocks with burnt umber and indigo. Touch in the distant gate, the fence, and the darkest shadows on the fields with mixes of burnt umber and French ultramarine.*

# Rivers

## Tree reflections in a river

Colors

burnt sienna
indigo
phthalo blue
cadmium lemon
phthalo green
cerulean blue

◀ **1** *Paint the sky and the top half of the water in burnt sienna. Paint the rest of the water with an indigo and phthalo blue mix. Paint the trees and meadow in a cadmium lemon, phthalo green, and burnt sienna mix.*

▶ **2** *Wet the distant trees, and paint cerulean blue, cadmium lemon, and indigo. Rub candle wax onto the center of the river when dry. Brush burnt sienna and phthalo green across the footpath. Roughly brush phthalo green and indigo across the trees. Paint the reflections with a loose wash of burnt sienna, cadmium lemon, phthalo green, and indigo.*

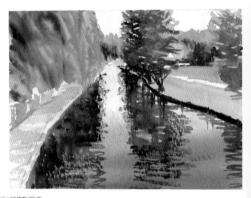

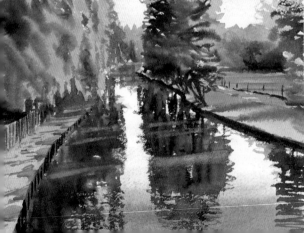

◀ **3** *Brush water on the meadow, and drop in indigo shadows. Paint grass clumps on the footpath in a phthalo green and cadmium lemon mix. Paint fence details and dark accents in the water in indigo. Paint ripples in an indigo and phthalo green mix. While using a damp brush, lift a few streaks of slanting sunlight from the water's surface.*

## Houses backing onto river

Colors

French ultramarine
burnt sienna
cobalt blue
cadmium lemon
phthalo green
burnt umber
titanium white

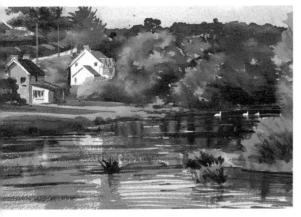

◀ **1** *Mask the swans. Wash a French ultramarine and burnt sienna mix over the paper, leaving the whites. When dry, begin to pick out house details and ripples on the water with a cobalt blue and burnt sienna mix.*

▶ **2** *Paint the greens with a mix of cadmium lemon, phthalo green, and burnt sienna. While this is still wet, paint the background hills with a French ultramarine and burnt umber mix. Paint the gable end and rough marks in the water in burnt sienna, and paint the dark window areas in a French ultramarine and burnt umber mix.*

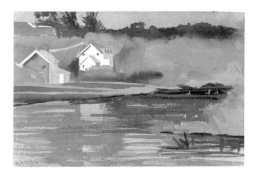

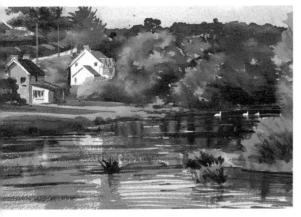

◀ **3** *Brush water onto the foliage areas, and brush on a French ultramarine and burnt umber mix. Paint horizontal brush strokes of a burnt sienna and cadmium lemon mix over the water. While this is still wet, paint rough streaks of burnt umber and French ultramarine across the surface. Remove the masking fluid, and brush on ripples of titanium white.*

# Rivers

Colors

## Wide, deep river

◀ **1** *Paint the sky wet into wet with a mix of cobalt blue, yellow ochre, and alizarin crimson, leaving the castle dry. Wet the river, and paint the sky color on the top half. Paint the lower half with yellow ochre.*

▶ **2** *Paint the castle with yellow ochre and cobalt blue, French ultramarine and Indian red on the tower sides. Wet the river, add gum arabic, yellow ochre and cobalt blue for castle reflections. Mix burnt sienna and French ultramarine for the dark trees, burnt sienna and cadmium lemon for the lighter trees.*

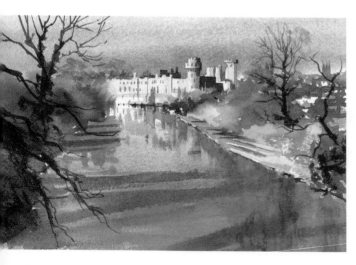

◀ **3** *Paint the trees with mixed French ultramarine and Indian red, the grass with French ultramarine and cadmium lemon, and the town with French ultramarine and burnt sienna. Wet the river, add cobalt blue and burnt sienna to the foreground, then tree reflections with French ultramarine and burnt sienna. Paint shadows onto the river's surface.*

# Broad river in the sun

Colors

alizarin crimson · cobalt blue · phthalo blue · new gamboge · phthalo green · cobalt turquoise · indigo · sepia · cerulean blue · burnt sienna

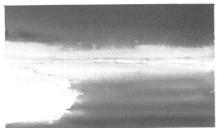

◀ **1** *Paint the lower part of the sky wet into wet in alizarin crimson and leave to dry. Paint the sky in mixed cobalt blue and phthalo blue. Paint the water wet into wet with mixed cobalt blue and phthalo blue. Leave to dry.*

▶ **2** *Brush new gamboge over the foliage, riverbank, and distant hill. While this is still damp, brush phthalo green on the riverbank and cobalt turquoise onto the distant hill. Leave to dry. Paint the ripples on the water in mixed phthalo blue and indigo, and the trees in indigo and sepia. Brush streaks of cerulean blue across the most distant part of the river.*

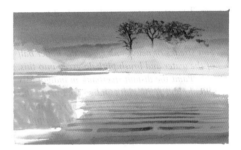

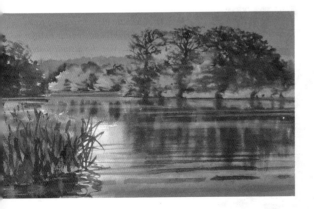

◀ **3** *Dry brush water across the woodland areas, and paint the trees in mixed phthalo green and indigo. Rewet the water area and paint the riverbank reflections in vertical streaks of new gamboge, burnt sienna, indigo, and phthalo green. Roughly paint the reeds and their reflections in indigo and phthalo green. When the river is dry, drag a damp brush across it to lift off highlights.*

# Rivers

## Sunlit river in woodland

Colors

new gamboge
phthalo blue
phthalo green
indigo
cobalt turquoise

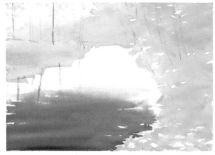

◄ **1** *Dampen the paper and wash new gamboge over the trees, leaving some patches of white. Working upward from the bottom of the paper, paint the lower half of the water with a graded wash of phthalo blue, again leaving a few patches of white. Leave to dry.*

► **2** *Spatter water over the group of trees on the left, and spatter phthalo green onto this area. Paint the left-hand riverbank in phthalo green. Paint streaks of new gamboge on the upper half of the water and brush phthalo green into this. Paint the distant riverbank in indigo. Mix phthalo blue with a little indigo, and brush this wet on dry across the foreground water to indicate ripples.*

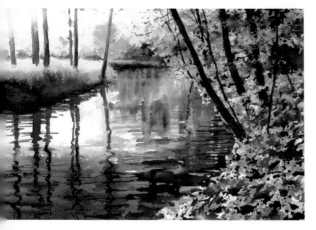

◄ **3** *Drag candle wax across the tree trunks on the right, and spatter indigo over the foliage. Wet the distant water area and drop in phthalo green, cobalt turquoise, and indigo. Darken the riverbank sides with indigo. Paint the tree trunks on the left in new gamboge; while wet, paint them in indigo upward from the bases. Rewet the water and add new gamboge, phthalo green, and indigo. When this is dry, paint the darkest ripples and sharp reflections in mixed indigo and phthalo blue.*

**Colors**

# Lone fisherman

◀ **1** *Brush water into the river and sky, and paint a blue gray mix of French ultramarine, alizarin crimson, and burnt sienna. Carefully apply the paint avoiding both the rocks and the fisherman.*

▶ **2** *Wet the distant mountain, and add a mix of French ultramarine, yellow ochre, and alizarin crimson, letting it bleed from the top downward. Paint the trees wet on dry with French ultramarine and yellow ochre to form a dark green. Add burnt sienna to their base wet into wet, defining the tops of the distant rocks with a hard, dry edge. Brush streaks across the water wet on dry with a French ultramarine, alizarin crimson, and burnt sienna mix to form a dark violet.*

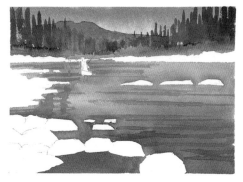

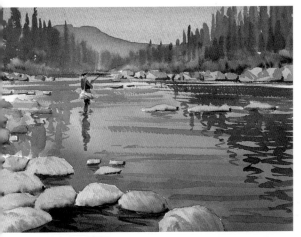

◀ **3** *Wet the foreground rocks, and add a light gray mix of Naples yellow, cobalt blue, and burnt sienna to the shadow sides. Use this for the distant rocks and for the fisherman's bag and head. Paint a mix of yellow ochre and French ultramarine for the tree reflections with a brush point wet on dry. Leave to dry. Brush the rocks with a mix of French ultramarine and burnt sienna and paint the figure with the same mix. Carefully paint the distant rock shadows in a cobalt blue and burnt sienna mix.*

# Footbridge over shallow stream

Colors

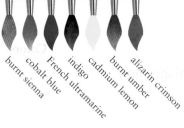

burnt sienna · cobalt blue · French ultramarine · indigo · cadmium lemon · burnt umber · alizarin crimson

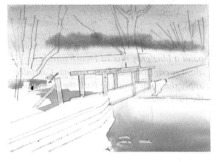

◄ **1** *Mask the bridge, masonry courses, stones, and cascading water. Wash burnt sienna over the top half of the paper, then cobalt blue wet into wet on the sky, and finally French ultramarine along the horizon. Wash a graded cobalt blue and burnt sienna mix onto the water.*

► **2** *Paint the grass with a mix of French ultramarine, cadmium lemon, and burnt umber. Paint the foliage on the left and the ground beyond the bridge in burnt sienna and alizarin crimson. Paint the wall, trees, and dark area around the bridge with French ultramarine and burnt umber. Dry brush ripples on the water, using indigo in the distance and indigo with cobalt blue in the foreground.*

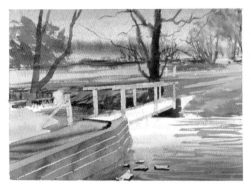

◄ **3** *Wet the reflection under the bridge, drop in burnt sienna and cadmium lemon, then brush in horizontal marks in French ultramarine. Drag color down onto the dry part of the paper and paint the tree reflection. Remove masking. Paint the bridge with a mix of pale cobalt blue and burnt sienna and finish the foliage in French ultramarine and burnt umber.*

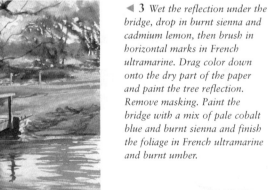

## Colors

# Masonry bridge over water

Naples yellow
quinacridone red
cobalt blue
burnt sienna
cadmium lemon
phthalo green
indigo

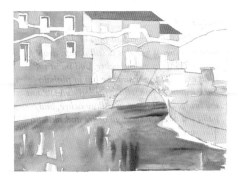

**1** *Paint the houses using Naples yellow mixed with quinacridone red, and pale cobalt blue. Paint the roofs in a burnt sienna and Naples yellow mix, and the sunlit masonry in a pale Naples yellow, cobalt blue, and burnt sienna mix. Paint the water using cadmium lemon, burnt sienna, phthalo green, and indigo; apply the colors separately and leave some whites.*

**2** *Paint the underneath of the arch and its reflection with indigo. Add cadmium lemon and burnt sienna, wet into wet, to the water. Paint the windows, the gaps between the balustrades, and the shadows under the roofs and on the walls in a mix of cobalt blue and burnt sienna. Wet the branch and add shade underneath.*

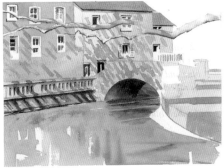

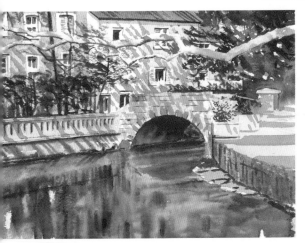

**3** *Paint foliage in phthalo green and indigo, the bridge and the wall on the right with cobalt blue and burnt sienna. Paint indigo lines on the wall and bridge. Wet the water and add burnt sienna, cadmium lemon, indigo, and phthalo green, wet into wet.*

Bridges

## Large river bridge

Colors

cobalt blue
phthalo blue
yellow ochre
Payne's gray
light red

◀ **1** *Paint the sky cobalt blue and the river phthalo blue. While this is still damp, drop gum arabic into yellow ochre, and paint the bridge's reflection. Paint the hill in phthalo blue, leaving a few whites for buildings. Paint the bridge and houses in yellow ochre, and paint the trees in a yellow ochre and phthalo blue mix. Leave to dry.*

▶ **2** *Rub streaks of candle wax across the river. Wet the river. Add reflections of mixed phthalo blue and Payne's gray, and yellow ochre in the arch reflection. Paint the rooftops light red. Rub wax onto the bridge parapet. Brush yellow ochre and cobalt blue over it and the wall on the right. Brush Payne's gray on the trees.*

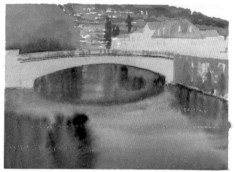

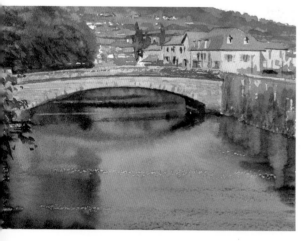

◀ **3** *Rewet the water, and brush on horizontal streaks of Payne's gray. Brush a cobalt blue and yellow ochre mix on the shadow sides of the houses, and pick out details in Payne's gray. Darken the trees with a Payne's gray and phthalo blue mix. Darken the wall to the right with a mix of Payne's gray, phthalo blue, and yellow ochre.*

# Covered bridge

Colors

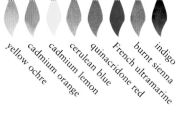

yellow ochre
cadmium orange
cadmium lemon
cerulean blue
quinacridone red
French ultramarine
burnt sienna
indigo

◀ **1** *Sketch the basic shapes in pencil, then paint a variegated wash of yellow ochre, cadmium orange, and cadmium lemon wet into wet, leaving the river, track, and bridge in white. Leave to dry.*

▶ **2** *Brush cerulean blue onto the river wet on dry. Lightly brush marks on the ground, using a violet mix of quinacridone red and French ultramarine. Paint foliage with a mix of cadmium lemon and cadmium orange, adding streaks of burnt sienna. Brush French ultramarine wet into wet into the foliage and in the gaps between the distant trees. Dry brush burnt sienna onto the bridge and leave to dry.*

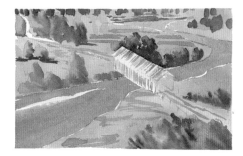

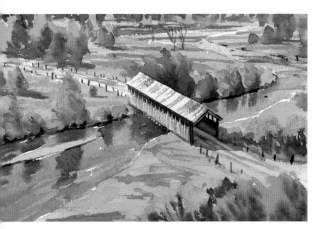

◀ **3** *Brush burnt sienna on the roadway in the bridge. Paint streaks with a mix of indigo and cerulean blue onto the river, then brush these with indigo reflections wet into wet. Add streaks of cerulean blue to the river in the distance wet on dry. Define the darks in the bridge with indigo. Highlight the marker posts and dead trees with a mix of burnt sienna and French ultramarine.*

Ponds and lakes

Colors

## Goldfish in a pond

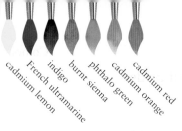

cadmium lemon
French ultramarine
indigo
burnt sienna
phthalo green
cadmium orange
cadmium red

**1** Mask two surfacing fish. Paint the lilies in a pale cadmium lemon. Wet the area around the lilies, and then soak with French ultramarine. While the paint is still wet, brush in indigo, taking care not to touch the lilies. Paint the pond edge in a light wash of burnt sienna.

**2** Roughly paint a mix of phthalo green, cadmium lemon, and burnt sienna on the lilies. Remove color from the fish by dabbing with a damp brush and a paper towel. Lift out some vertical highlights from the water by stroking a damp brush firmly downward and dabbing with a paper towel.

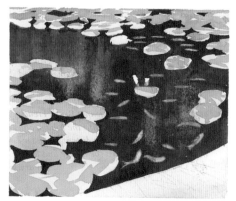

**3** Touch in the fish with cadmium orange, then cadmium red. Roughly brush darker shadow colors on the lilies in a mix of phthalo green and burnt sienna. Paint shadows across the scene in French ultramarine.

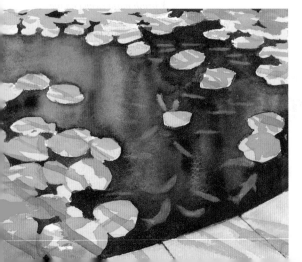

## Clear water pond

Colors

cobalt blue  
burnt sienna  
Naples yellow  
phthalo green  
Payne's gray

◀ **1** Mask the foreground, fences, and some trees. Paint a blue-biased cobalt blue and burnt sienna mix over the sky and water.

▶ **2** Wet the woodland, and paint it with cobalt blue, burnt sienna, Naples yellow, and phthalo green, letting the colors merge on the paper. Let the paint dry, then remove the masking fluid. Paint the reflection area with Naples yellow. Add phthalo green while wet and paint the reflections. When dry, paint burnt sienna ripples on the near part of the pond.

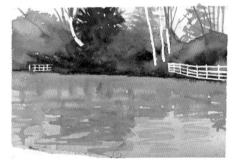

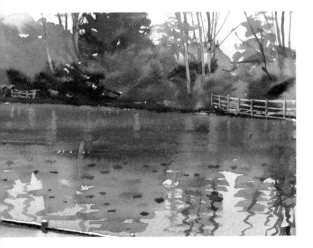

◀ **3** While still wet, deepen the pond color with a mix of phthalo green and burnt sienna. Add Payne's gray, and paint the tree trunk reflections. Dab dark spots of Payne's gray in the water for dark stones. Touch in the fence and trees with a little burnt sienna and phthalo green. Remove the masking fluid.

Ponds and lakes

## Rippling pond in woodland

Colors

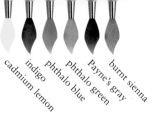

cadmium lemon
indigo
phthalo blue
phthalo green
Payne's gray
burnt sienna

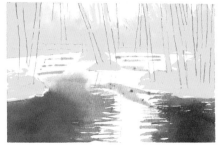

◀ **1** *Mask mud banks in the water. Wash strong cadmium lemon across the foliage. Paint the water wet on dry with a mix of indigo and phthalo blue, making ripple shapes in the patch of reflected sunlight. Leave to dry.*

▶ **2** *Roughly spatter the foliage with a mix of phthalo green and cadmium lemon. When dry, repeat with phthalo green and Payne's gray. Dampen the water area on the left to halfway down. Drop in cadmium lemon, phthalo green, Payne's gray, and burnt sienna. Drag ripples across the paper below the wet area. Paint the background tree trunks and their reflections in burnt sienna and phthalo green.*

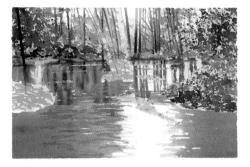

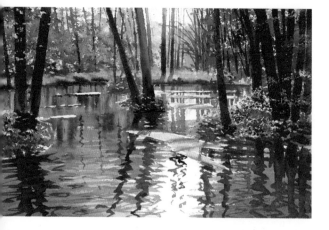

◀ **3** *Paint the nearest trees and their reflections with a phthalo green and Payne's gray mix. Brush a crisscross pattern of ripples in the foreground with a Payne's gray and phthalo blue mix. Touch in the mud banks with a warm mix of burnt sienna and Payne's gray, and paint more ripples in a paler version of the same mix.*

# Woodland puddles

alizarin crimson
phthalo green
Naples yellow

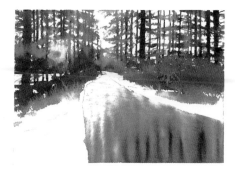

◄ **1** *Mask the Sun. Drag a damp brush across the paper's top half, and brush the tree trunks with mixed alizarin crimson and phthalo green. Brush Naples yellow and alizarin crimson around the Sun. Wet the lane, then brush in crimson, and paint strokes of phthalo green for the tree reflections.*

► **2** *Paint the banks with Naples yellow. Paint strokes of phthalo green on the grass and alizarin crimson below the trees, wet into wet.*

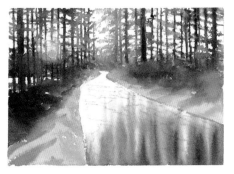

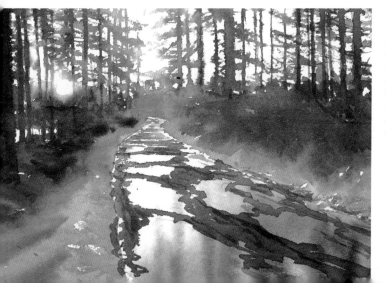

◄ **3** *Paint the lane in a darker mix of alizarin crimson and phthalo green, leaving holes for the puddles. Remove the masking fluid from the Sun.*

# Ponds and lakes

Colors

## Sunset lakes and mountains

new gamboge · Naples yellow · cobalt blue · burnt sienna · sepia · phthalo blue

◀ **1** *Mask the Sun. Cover the entire paper with a wash of new gamboge mixed with a little Naples yellow. While this is still wet, add burnt sienna along the horizon and loosely brush a mix of cobalt blue and burnt sienna over the water, leaving a gap for the Sun's reflection.*

▶ **2** *Loosely brush water onto the sky, leaving some dry streaks, and brush separate strokes of cobalt blue, burnt sienna, and Naples yellow onto the damp areas. Add burnt sienna to the horizon. Paint streaks of cobalt blue on the distant water and dry brush mixed cobalt blue and burnt sienna ripples onto the foreground and burnt sienna below the Sun's reflection. Brush water into the cloud shapes and drop in mixed cobalt blue and burnt sienna. Remove the masking.*

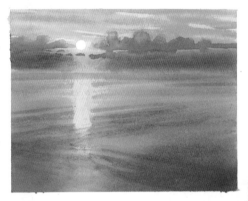

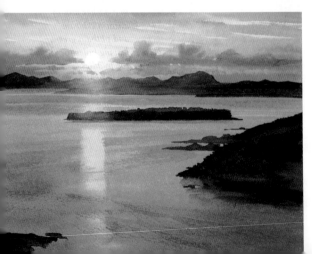

◀ **3** *Mix sepia and phthalo blue and paint the dark masses of the islands and mountains, adding water and burnt sienna to the area below the Sun and keeping the color pale and transparent.*

Colors

# Still, deep lake

◀ **1** Mask a long, thin line along the shore. Paint the trees and shoreline above the water in new gamboge and leave to dry. Apply a phthalo blue wash over the sky and mountains, leaving whites for snow. While the sky is still wet, lift out wisps of clouds with tissue paper. Wet the water area and apply a graded wash of phthalo blue, working upward. While this is still wet, paint the shoreline reflection in a dilute mix of new gamboge.

▶ **2** Brush water over the mountain on the left. Mix a little quinacridone red and burnt sienna with French ultramarine, and paint the mountain, leaving the snow areas white. Add new gamboge to the wash and paint the lichen-clad cliff. Dampen the water area and drop on phthalo blue, leaving some of the lighter shoreline reflections showing through. Leave to dry.

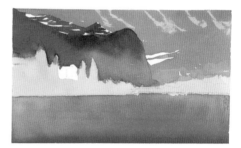

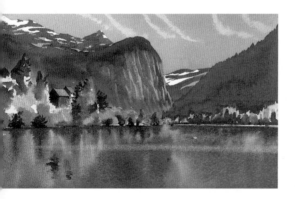

◀ **3** Paint the central and right-hand mountains in a mix of French ultramarine and quinacridone red. Use the same mix for the dark shoreline forest. Paint vertical strokes of French ultramarine mixed with phthalo green on the left cliff. Paint the house with a mix of quinacridone red and burnt sienna, and the roof with a mix of French ultramarine and burnt sienna. Rewet the lake and paint the reflections with vertical brush strokes, using the same colors as before. Remove the masking.

Colors

## Rowing boat in woodland

◄ **1** *Mask the boat. Paint the sky in cobalt blue, the water in a phthalo blue and indigo mix, and the grass areas in cadmium lemon with a little burnt sienna in the foreground. Leave to dry.*

► **2** *Paint the trees in a mix of cadmium lemon, burnt sienna, and cerulean blue, and brush on indigo for the dark areas. Wet the upper part of the reflection area and add the tree colors, brushing them down vertically. While using the same colors and the tip of the brush, paint ripples across the water. Leave to dry, then remove the masking fluid.*

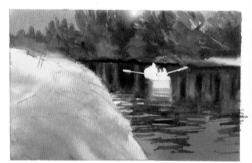

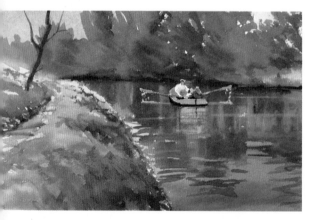

◄ **3** *Paint the boat and its reflection in a cadmium lemon and burnt sienna mix. Paint the figures in a cadmium lemon and burnt sienna mix with spots of dilute indigo and cadmium red. Lift off paint for the ripples under the oars with a damp brush, and scratch off drips of water with a craft knife. Wet the riverbank, and drop in phthalo green, burnt sienna, and indigo. When dry, add a few more dark details on the figures and the boat in indigo, and paint the tree in a mix of cadmium lemon, burnt sienna, cerulean blue, and a little indigo.*

## Colors

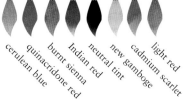

cerulean blue
quinacridone red
burnt sienna
Indian red
neutral tint
new gamboge
cadmium scarlet
light red

# Beach boat

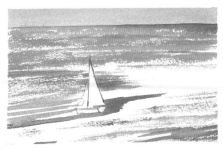

◀ **1** *Paint the sky down to the horizon line in cerulean blue and leave to dry. Dry brush the sea with a mix of cerulean blue and quinacridone red, varying the color. Add a little burnt sienna to the foreground water. Dry brush Indian red onto the beach and brush in some cerulean blue shadow.*

▶ **2** *Paint the rocks with neutral tint. Paint the pine foliage in new gamboge using the drybrush technique, the figures in light red and gray mixed from cerulean blue and light red, and the sail in cadmium scarlet.*

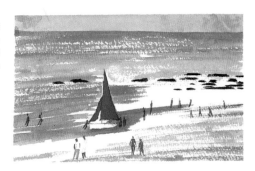

◀ **3** *Add a little cerulean blue to the pine foliage and brush in the branches and some pine needles with neutral tint. Paint the boat and its reflection with neutral tint and add a little cadmium scarlet to the water below it. Add neutral tint detail to the figures.*

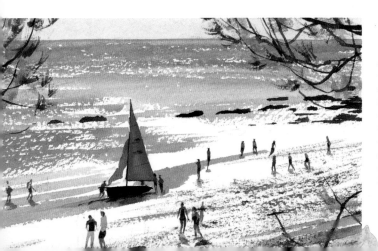

# Boats and ships

Colors

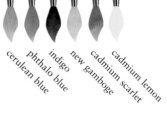

*cerulean blue* *phthalo blue* *indigo* *new gamboge* *cadmium scarlet* *cadmium lemon*

## Trawlers

◀ **1** *Mask all the white masts and uprights. Mix cerulean blue and phthalo blue, and paint the sky boldly wet on dry. Wet the harbor and paint it with the same mix used for the sky. Then brush on a few vertical streaks of indigo.*

▶ **2** *While using a mix of indigo and new gamboge, dry brush the tall dark trees behind the boats. When they are dry, paint a few dark masts and lines in indigo and the shaded sides of the boats' hulls in cerulean blue. Remove the masking fluid. Start painting the colors on the boats using cadmium scarlet.*

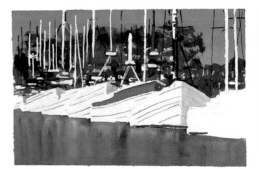

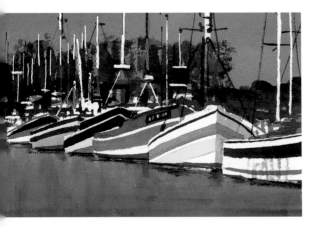

◀ **3** *Finish the boats with a variety of colors—indigo, cadmium lemon, phthalo blue, and cadmium scarlet. Dry brush a little indigo into the water along the waterline, and use the same color to darken the bottoms of the boats where they touch the water.*

# Beached boat on pebbles

Colors

quinacridone red / phthalo blue / French ultramarine / burnt sienna / cobalt blue / cadmium lemon / phthalo green / indigo / cadmium scarlet / titanium white

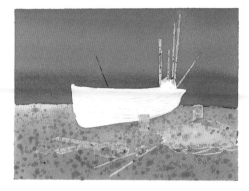

◀ **1** *Mask the objects on the beach. Paint the beach in burnt sienna. Wet the sky and paint quinacridone red along the horizon. While still wet, brush phthalo blue over the sky and sea, adding French ultramarine from the horizon down. Cover the boat and sky. Spatter masking fluid over the beach, making the droplets smaller in the distance.*

▶ **2** *Wash a burnt sienna and cobalt blue mix over the beach. When dry, spatter the beach with masking fluid. Paint the boat in burnt sienna, with cadmium lemon for the highlights. Remove the masking from the fishing nets, and paint in a mix of phthalo green and indigo. Paint the sea in phthalo blue, adding indigo in the middistance and burnt sienna in the foreground.*

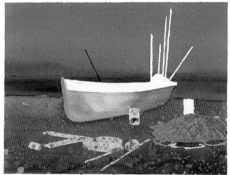

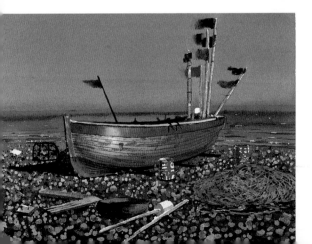

◀ **3** *Paint indigo lines on the fishing nets. Finish the boat in burnt sienna, adding cobalt blue at the base. Paint the poles in cadmium lemon and the flags in indigo or cadmium scarlet. Paint the beach in a mix of burnt sienna and phthalo blue. Paint indigo shadows between a few of the stones. Remove all masking. Paint the driftwood in a mix of cobalt blue and burnt sienna, the cans in cadmium scarlet, and the waves in titanium white.*

## Small boat by pier

Colors

*sepia*  *phthalo green*  *burnt sienna*  *Payne's gray*

◀ **1** *Wet the paper, leaving the boat dry. Brush on a mix of sepia and phthalo green from the bottom upward, letting it fade toward the top.*

▶ **2** *Use the same mix to paint the piers and their reflections. Add burnt sienna to the mix, and paint the boat, adding darker color to the bottom of the boat and letting it spread upward. Leave to dry. Then paint more detail using a darker version of the same mix.*

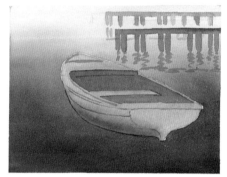

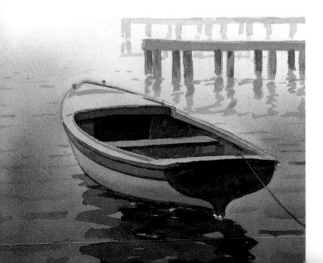

◀ **3** *Add a little Payne's gray to the mix for the darkest tones on the boat and the reflection. Using the same mix, brush a few ripples on the water, and paint the rope.*

# Tall ship at rest

Colors

cobalt blue · burnt sienna · Indian red · French ultramarine · Naples yellow · light red · indigo

◀ **1** Wet the paper, avoiding the boat. Paint in a mix of cobalt blue and burnt sienna, leaving the whites. Add plenty of color directly behind the boat.

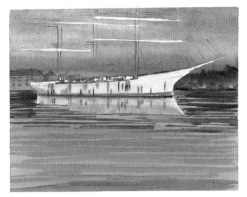

▶ **2** Paint the foreground ripples and shore detail in a mix of cobalt blue and burnt sienna. Paint the shore on the right and the dark ripples in a mix of Indian red and French ultramarine. Paint the hull in Naples yellow and its reflection in Naples yellow and a little cobalt blue. Then brush on vertical streaks of light red and indigo, wet into wet. Paint the deck detail in burnt sienna.

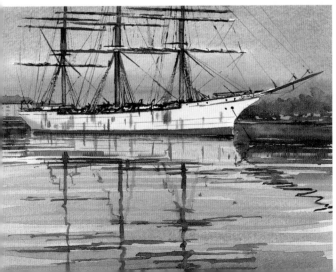

◀ **3** Paint the masts and rigging in a mix of French ultramarine and Indian red, using a rigger brush. Use the same color for the rippling reflections.

## Sailing boats in harbor

Colors

phthalo green  burnt sienna  indigo  cobalt blue  alizarin crimson

◄ **1** *Rub candle wax across the central part of the water. Wet the sky and the shore area, leaving large, dry patches for boats. Paint the sky, shore, and sail in mixes of phthalo green and burnt sienna. When dry, paint the water with a mix of phthalo green, burnt sienna, and indigo.*

► **2** *While the water is still wet, brush on indigo reflections. Paint the shore around the boats with a loose wash of phthalo green, burnt sienna, and indigo. When this is dry, paint the boats with a blue gray mixed from cobalt blue and burnt sienna, leaving the highlights white. Then paint the distant trees with a mix of phthalo green and burnt sienna. Paint the sail in alizarin crimson.*

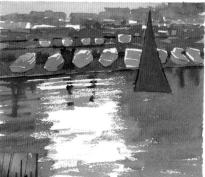

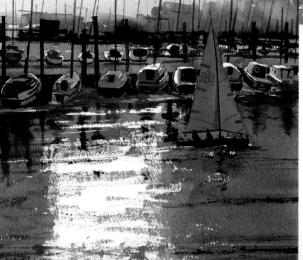

◄ **3** *Paint dark details and reflections of the boats and the detail on the red sail in indigo. Paint the distant masts in burnt sienna. Use the tip of a craft knife to scratch a few highlights in the water.*

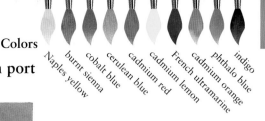

## Colors

# Mooring in Mediterranean port

◀ **1** *Paint the buildings in Naples yellow, adding burnt sienna, wet into wet, in places. Paint the water in a mix of Naples yellow and a very small amount of cobalt blue. When the buildings are dry, paint the sky in cerulean blue, carefully painting around the buildings on the skyline.*

▶ **2** *Paint the blue in the water with cerulean blue. Paint the detail in the buildings with a mix of cobalt blue and burnt sienna. Paint the dome in a mix of cadmium red and burnt sienna. Paint cadmium lemon stripes on the boats and cadmium red and French ultramarine marks for the bright colors and people on the shore.*

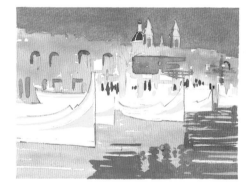

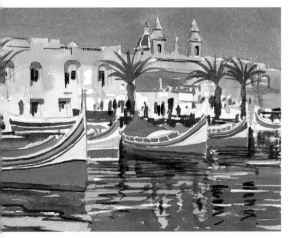

◀ **3** *Finish the boats using cadmium red, cadmium orange, indigo, and a mix of cerulean blue and phthalo blue. Paint the windows in indigo, the palm trees in burnt sienna, and the fronds in cadmium lemon and cobalt blue. Paint the reflections in the harbor in cadmium red, indigo, and mixes of burnt sienna, cobalt blue, and cerulean blue.*

## Calm water sailing boats

quinacridone red
phthalo blue
burnt umber
alizarin crimson
yellow ochre
French ultramarine
Naples yellow
indigo
cobalt blue
burnt sienna

◀ **1** *Brush a pale wash of quinacridone red over everything except the boats. Leave white patches in the middle of the water and the right side of the sky. When dry, repeat, using phthalo blue, dark in the top left corner of the sky, and very dark at the bottom of the water, adding burnt umber and alizarin crimson, or indigo, here. Be careful to avoid the light shapes of the boats.*

▶ **2** *Brush streaks of phthalo blue across the foreground water to give the ripples of sky reflection. Work the background hill wet into wet, using burnt umber, yellow ochre, and French ultramarine, getting paler toward the right. When dry, add the reflection with the same colors run together with Naples yellow and indigo, each added in vertical streaks. Using the edge of a card as a guide, lift the masts with a damp bristle brush, and dab with dry tissue. Repeat in the water. Brush in the darker parts of the masts.*

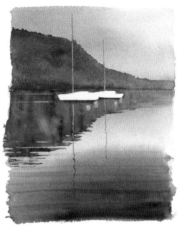

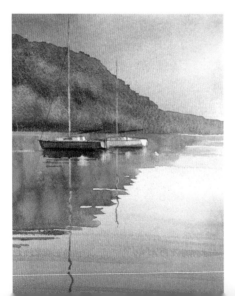

◀ **3** *Paint in the details of the boats with grays from cobalt blue and burnt sienna biased brown or blue. Paint shadows on the undersides of the boats with indigo while wet. Loosely brush in the dark reflections.*

# Cruise liner

cobalt blue · alizarin crimson · yellow ochre · phthalo blue · Naples yellow · light red · phthalo green · indigo · burnt sienna

◀ **1** *Mask the wake of the launch heading out towards the liner. Paint the sky and sea in a mix of cobalt blue, alizarin crimson, and yellow ochre, leaving the liner white. Add phthalo blue only to the top of the sea. Paint the roofs on the right in a mix of Naples yellow and light red. When dry, paint the walls, foreground roof, and distant hill in a mix of Naples yellow and cobalt blue.*

▶ **2** *Paint the sea and harbor in a mix of phthalo green, phthalo blue, and indigo, leaving the liner white. When this is dry, paint the liner and distant hills in a gray mixed from cobalt blue, alizarin crimson, and burnt sienna. Paint the darker town walls in a mix of cobalt blue and Naples yellow, and deepen some of the roof tones. Paint the nearby headlands in a mix of indigo and phthalo green.*

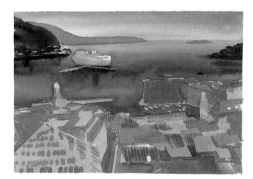

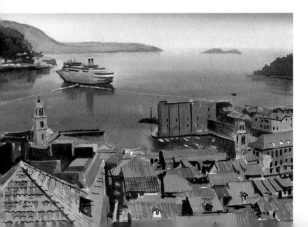

◀ **3** *Wet the lower half of the ship's hull, and add indigo along the bottom. While using the tip of your brush, paint the dark architectural detailing in the town and on the ship in indigo, and the funnels in yellow ochre. Remove the masking from the wake of the launch. Extend the wake outward by gently lifting off paint with a fine-pointed brush dipped in clean water.*

# Boats and ships

Colors

quinacridone red
cobalt blue
phthalo blue
phthalo green
indigo
burnt sienna
Naples yellow
Payne's gray
cadmium red
titanium white

## Ship in full sail

◄ **1** *Wet the paper, avoiding the ship. While working from the horizon upward, lay a graded wash of quinacridone red to about halfway up the sky. Add a line of cobalt blue along the horizon. Brush a mix of phthalo blue and cobalt blue onto the sky, working carefully around the ship. When dry, paint the sea leaving flecks of white.*

► **2** *Loosely paint the waves in a mix of phthalo green and indigo. Add phthalo blue for the distant sea up to the horizon. Wet the sails, and paint the lower edges with a mix of cobalt blue, burnt sienna, and Naples yellow. When dry, paint fine lines of Payne's gray along the lower edges. Paint the hull with Naples yellow, adding cobalt blue, wet into wet, to the stern.*

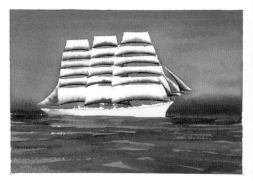

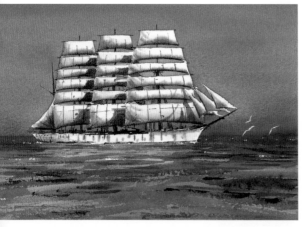

◄ **3** *Brush a few indigo lines onto the sea. Brush streaks of light cadmium red and Payne's gray streaks onto the hull. Build tone on the sails with a mix of burnt sienna, cobalt blue, and Naples yellow, wet into wet for the shadow. Paint the dark detail of the rigging in Payne's gray and the birds in titanium white.*

Colors

# Ocean racer at sea

◀ **1** *Wet the paper and apply a cobalt blue wash slightly grayed with burnt sienna, leaving the boat white.*

▶ **2** *Streak in the sea detail with the same color and darken, making it very dark near the horizon.*

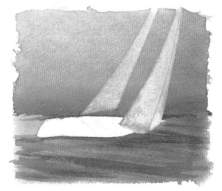

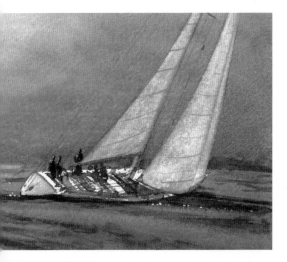

◀ **3** *Scrub out the sails and mast and dab with tissue. Paint in the delicate sail detail and draw rigging with a sharp "B" pencil. With the point of a brush, sketch the deck detail and figures. Paint the underside of the boat. Add the dark shadow from the sail and a dark streak behind the boat in Payne's gray. Brush a pale shadow of cobalt blue and burnt sienna onto the stern. Add a wash of yellow ochre and light red over the entire scene, avoiding the boat and sails. Go back and glaze the sails in the same color. Pick out a line of foam in the sea with the point of a knife.*

# Coastlines

Colors

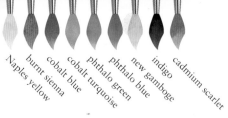

### Sunny harbor scene

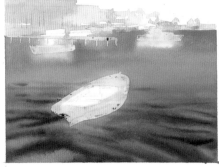

◀ **1** *Mask the boats and pier. Mix Naples yellow, burnt sienna, and cobalt blue, and paint the buildings. Wet the water area, brush gum arabic below the two most distant boats, and add Naples yellow to these areas. Mix cobalt turquoise, phthalo green, and phthalo blue, and brush this loosely onto the water area. While the water is still wet, paint the foreground ripples in a mix of indigo and phthalo blue.*

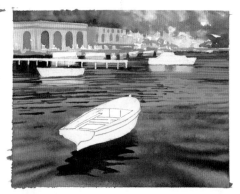

▶ **2** *Remove the masking. Pick out architectural details with mixes of cobalt blue and burnt sienna. Brush mixed new gamboge and Naples yellow into the area behind the buildings and add a mix of phthalo green and indigo. Mix phthalo green, phthalo blue, and indigo. Working wet on dry, paint the ripples and the nearest boat's reflection with a fine-pointed round brush.*

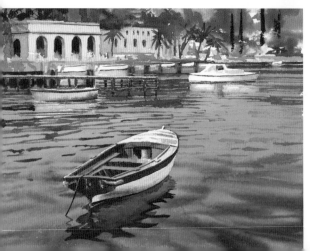

◀ **3** *Paint the dark architectural details in indigo, and the palm trees in an indigo and phthalo green mix. Paint the pier in burnt sienna and the outside of the boats with Naples yellow and a little cobalt blue. Paint the inside of the nearest boat in burnt sienna, with indigo details. Add a little Naples yellow to the boat's reflection. Paint people in the distance with tiny specks of cadmium scarlet.*

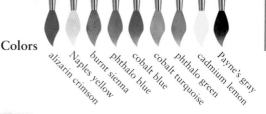

Colors

# Sandy cove

alizarin crimson · Naples yellow · burnt sienna · phthalo blue · cobalt blue · cobalt turquoise · phthalo green · cadmium lemon · Payne's gray

◀ **1** *Mask the rocks. Wet the entire paper. Mix alizarin crimson with a little Naples yellow, and paint the lower part of the sky wet into wet. Brush burnt sienna over the sand nearest the water and Naples yellow over the foreground sand.*

▶ **2** *Mix phthalo blue and cobalt blue. Working downward, paint as far as the base of the distant mountains, leaving patches of the underlying wash showing through on the mountains. While this is still wet, brush cobalt blue onto the mountains. Wet the sea area, and add cobalt turquoise. Add phthalo blue to the distant shoreline and burnt sienna mixed with Naples yellow to the nearby shore.*

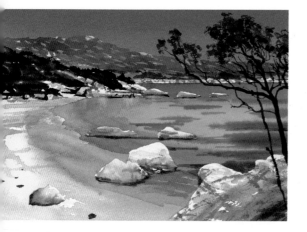

◀ **3** *Crisscross strokes of a cobalt blue and burnt sienna mix over the distant mountain. Paint the foliage on the near headland in phthalo green and cadmium lemon. Feather a little water onto the rocks in the sea and drop on burnt sienna. Dry brush cobalt blue on the foreground rock, adding burnt sienna while it is still damp. Paint the foreground trees with Payne's gray mixed with cadmium lemon.*

### Cloud banks over sunny cove

Colors

cobalt blue · yellow ochre · alizarin crimson · burnt sienna · French ultramarine

◄ **1** *Wet the sky and sea, and paint them in a gray mixed from cobalt blue, yellow ochre, and alizarin crimson. Keep the color slightly biased towards yellow near the tops of the clouds. Paint the beach and headland in a mix of burnt sienna and yellow ochre.*

► **2** *Use French ultramarine to paint around the horizontal streaks of cloud near the horizon. Wet the sky above the clouds, and brush on French ultramarine, carefully preserving the light edges of the clouds. Add a mix of cobalt blue, alizarin crimson, and burnt sienna to the undersides of the clouds, allowing the color to bleed into the wet sky in places. Paint the sea in French ultramarine up to the shoreline. Keep the sky and sea wet for the next stage.*

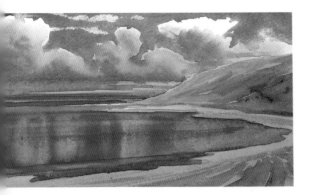

◄ **3** *Lift out the high clouds with tissue paper. Brush vertical streaks of gum arabic onto the sea: this will push aside color to form cloud reflections. Brush dark lines of a mix of yellow ochre and burnt sienna onto the beach. Darken the hill with a green mixed from cobalt blue and yellow ochre, and add dark accents in cobalt blue. When the sea is dry, add shadows of French ultramarine under the distant clouds and broad streaks of French ultramarine in the foreground.*

# Swans in harbor

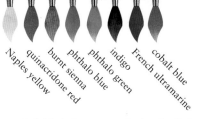

Naples yellow
quinacridone red
burnt sienna
phthalo blue
phthalo green
indigo
French ultramarine
cobalt blue

◀ **1** *Mask the swans and a few details in the harbor. Wet the entire paper, and add Naples yellow to the lower sky. Then add quinacridone red along the horizon, letting it spread upward. Wash the entire water area with burnt sienna, and add phthalo blue to the lower right-hand side.*

▶ **2** *Rewet the sky and water. Working downward, wash a mix of phthalo blue and phthalo green over the sky and water, leaving some lights in the shoreline buildings. Add indigo to the bottom right. When this is dry, brush burnt sienna over the harbor area. Using a damp brush, lift off color below the swans. Leave to dry. Dry brush strokes of mixed phthalo blue and indigo on the water.*

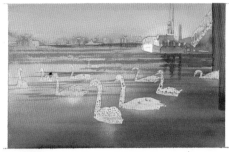

◀ **3** *Mix French ultramarine and burnt sienna, and paint the townscape. Paint ripples with a mix of phthalo blue and indigo. Remove the masking, and finish the boats. Brush dilute Naples yellow onto the swans, leaving some white. Paint one side of the swans' necks with burnt sienna, then darken with cobalt blue. Paint the beaks with burnt sienna. When dry, paint the dark detail in indigo.*

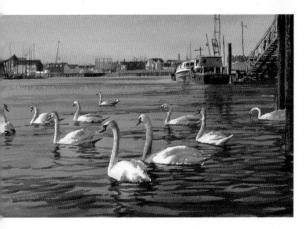

## Tropical bay

Colors

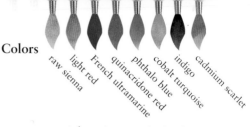

raw sienna · light red · French ultramarine · quinacridone red · phthalo blue · cobalt turquoise · indigo · cadmium scarlet

◀ **1** *Mask some palm fronds and figures on the beach. Wet the beach and headlands and paint in raw sienna. While this wash is still wet, brush light red streaks on the beach and add a little light red, followed by French ultramarine, to the distant hill.*

▶ **2** *Wet the sky and sea areas, and paint quinacridone red above the horizon to about halfway up the sky. Paint the sky, distant bay, and top half of the nearer bay in phthalo blue and the lower half of the nearer bay in cobalt turquoise. Leave to dry.*

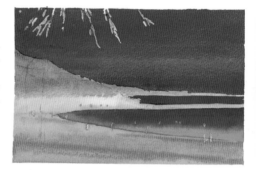

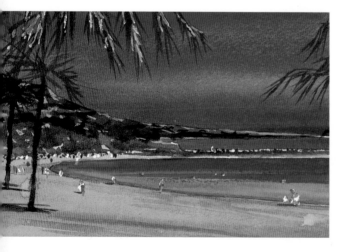

◀ **3** *Brush a mix of French ultramarine and light red onto the distant hill, adding dark indigo shadow marks while still wet. Paint the palm trees and the strip of land between the bays in a mix of indigo and raw sienna. Remove the masking fluid. Touch in the palm fronds with a mix of raw sienna and French ultramarine, and the figures with cadmium scarlet and light red.*

# Small boats in harbor

Colors

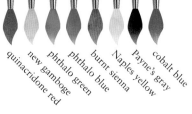

quinacridone red  new gamboge  phthalo green  phthalo blue  burnt sienna  Naples yellow  Payne's gray  cobalt blue

◀ **1** *Mask the small boats. Then highlight the large background boat, and thoroughly wet the water area. Loosely add quinacridone red, new gamboge, phthalo green, and phthalo blue, keeping the colors intense in the foreground and lighter in the distance.*

▶ **2** *Darken with a mix of phthalo green and quinacridone red wet into wet in the foreground. When this is dry, apply a wash of gray mixed from phthalo green and quinacridone red to the large boat, and a mix of burnt sienna and Naples yellow to the smaller one. Paint the ripples on the background water in phthalo blue, adding phthalo green, and then quinacridone red as you move toward the foreground. Leave to dry.*

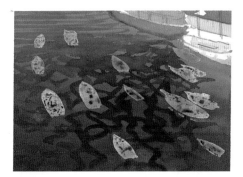

◀ **3** *Paint the dark reflections in Payne's gray. Finish the large boat with darker grays from the palette and burnt sienna for the warmer tones. Leave to dry. Remove the masking and touch in the boats using Naples yellow mixed with a little burnt sienna for the tarpaulin covers, and cobalt blue mixed with burnt sienna for the grays.*

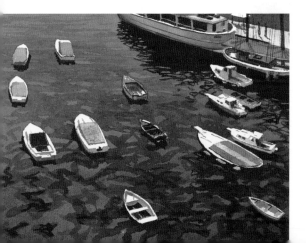

## Cliff scene

Colors

phthalo blue
phthalo green
new gamboge
indigo

◀ **1** *Mask the surf. Wet the sky and cliffs working downward, leaving gaps of dry paper on the cliffs. Then paint phthalo blue into this area, leaving some of the dry gaps white. Dab the sky with damp tissue to create the clouds, letting the wash bleed into the middistance to form a soft edge. Paint the sea with phthalo blue wet on dry, leaving additional white paper for the surf. Add phthalo green to the foreground. Drag the color with a dry brush technique to create the white flecks.*

▶ **2** *Paint the cliffs with new gamboge, working from the foreground into the distance. Leave a few gaps so that the whites and the sky wash show through. Leave to dry, then paint phthalo blue over the distant crags, covering the whites but leaving some gaps showing the new gamboge wash.*

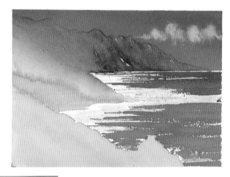

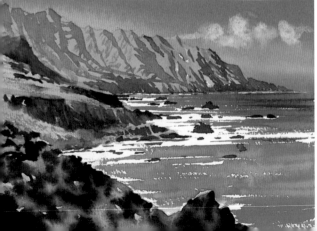

◀ **3** *Paint the distant crags with a mix of indigo and phthalo blue. Brush a crisscross wash of water over the foreground, leaving a few dry gaps, and loosely brush in indigo, leaving the underlying new gamboge showing in places. Use indigo for the middistance darks. Remove the masking fluid. Paint the rocks with indigo, and brush a few long streaks of phthalo blue into the white areas of the sea.*

## Pier at sunset

Colors

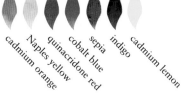

cadmium orange
Naples yellow
quinacridone red
cobalt blue
sepia
indigo
cadmium lemon

◀ **1** *Brush a circle of water around the outside of the Sun, and horizontal bars below it for its reflection. Wet the rest of the paper, leaving gaps around the damp ring and reflection, and lay a wash of cadmium orange, Naples yellow, and quinacridone red up to the gaps. Add cobalt blue to the right-hand corners. Brush a little more water around the Sun and its reflection to prevent a hard edge from forming.*

▶ **2** *Rewet the sky, again leaving gaps around the Sun and its reflection, and lay another wash of cadmium orange, Naples yellow and quinacridone red. Add a touch of cobalt blue to the top right-hand corner and along the horizon. When dry, paint the beach wet on dry with sepia and indigo, adding water and the orange sky color near the Sun's reflection.*

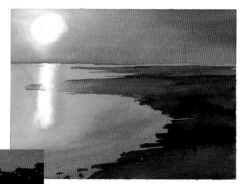

◀ **3** *Paint the pier, birds, and dark detail on the beach in sepia and indigo, leaving a gap in the pier for the halation effect of the Sun. Brush a little cadmium lemon on the edges of the Sun's reflection, leaving the middle as white paper. Paint ripples and reflections on the sea in a pale mix of indigo and sepia, adding cadmium orange near the Sun.*

# Sea and sky

## Silky early morning sea

**Colors**

cobalt blue · Payne's gray · phthalo green · burnt sienna · new gamboge · indigo

◀ **1** *Paint the area above the shoreline in cobalt blue, leaving a few whites. Paint a graded wash wet into wet from the bottom of the paper upward, using a mix of Payne's gray and phthalo green.*

▶ **2** *Paint the distant mountain in a mix of burnt sienna and cobalt blue, adding a wash of new gamboge lower down the slopes and leaving the houses white. Add the masses of dark foliage in indigo, wet into wet.*

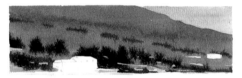

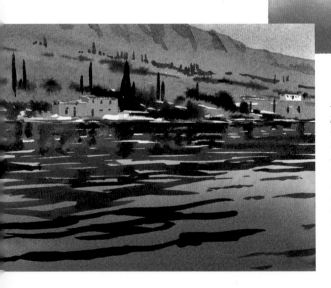

◀ **3** *Add pale cobalt blue shadows to the mountains, and paint the house walls in a mix of cobalt blue and burnt sienna. Paint the cypress trees and architectural detail in indigo, wet on dry, using the tip of the brush. Paint the roofs in burnt sienna. Brush dark ripples on the water with a strong indigo, wet on dry, and add new gamboge near the shore.*

# Tide pools

◀ **1** *Wet the paper all over, and apply a first wash of Naples yellow, paler on the lighter parts. While still wet, add a second wash mixed from cobalt blue and burnt sienna. Apply the colors in varying strengths, keeping the left side darker and the right lighter. A third wash of French ultramarine is added in places for extra darkness.*

▶ **2** *Paint the town backdrop wet into wet using the second wash, then pick out the skyline detail wet on dry. Paint the sand below with a lighter version of the same wash, streaked wet on dry. The wet reflection of the town and pier is brushed into a wet wash with added gum arabic, and the paint is streaked down vertically.*

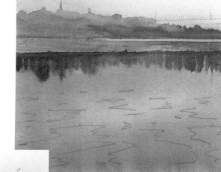

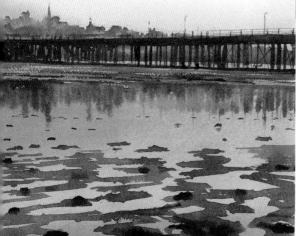

◀ **3** *A few darker streaks painted horizontally across the mud give the pools of water. Brush the pier in loosely with a dark French ultramarine, and streak across the foreground mud and rocks. Bear in mind an aerial perspective and make the shapes diminish in size over distance. Stones are brushed in at this stage.*

Naples yellow / cobalt blue / burnt sienna / French ultramarine

Sea and sky

## Surf breaking on rocks

Colors

cobalt blue
burnt sienna
new gamboge
Payne's gray
indigo

◀ **1** *Build up the basic shapes with a mix of cobalt blue and burnt sienna, adding new gamboge wet into wet in the middle ground where the sunlight catches the surface of the sea.*

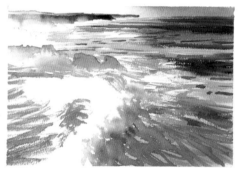

▶ **2** *Wet the distant cliffs, and paint them in a very watery mix of new gamboge, cobalt blue, and burnt sienna. While this is still wet, add Payne's gray in places, leaving gaps for the spray mist from the heaving surf. Dry brush a mix of cobalt blue and burnt sienna over the foreground, and paint contrasting darks in the water in indigo.*

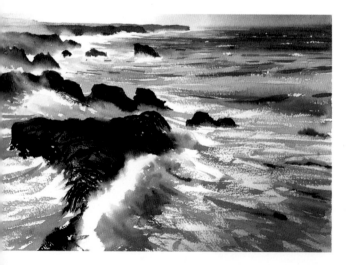

◀ **3** *Wet the rocks. Drop on Payne's gray, leaving blurred, soft edges where the surf washes against them and sharp edges where they are brushed by the waves. Use all the colors in the palette to add darker accents to the sea. The dark rocks define the white surf.*

Colors *cerulean blue* *burnt sienna* *light red*

# Rock pools on stormy beach

◀ **1** *Wet the entire paper and brush in sky and water areas using a wash of cerulean blue with a touch of burnt sienna.*

▶ **2** *Using the same wash, paint the headlands one at a time, starting with the most distant and allowing each to dry in between. Paint the undersides of the waves. The foreground is painted with light red and cerulean blue for good granulation and texture.*

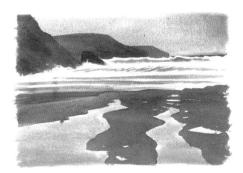

◀ **3** *Add darks beneath the curling waves; place rocks in the surf and by the rock pools. Brush a few reflections into the water in the rock pools. A little more definition may be brushed into the headlands.*

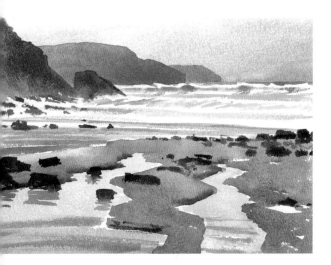

## Rocky pool with reflection

Colors

phthalo blue
cobalt blue
burnt sienna
light red
phthalo green

◀ **1** *Using a toothbrush, spatter droplets of masking fluid onto the foreground. Paint sky and water with phthalo blue, darkened along the horizon with a gray of cobalt blue and burnt sienna.*

▶ **2** *Apply a wash of burnt sienna over all white areas of the paper. Spatter more masking fluid onto the shingle. Rewet the rocks and add a gray from cobalt blue and burnt sienna to their shadow sides. The rocky backdrop is painted wet into wet with the same color, and streaks of blue make gentle blue sky ripple reflections. When the masking fluid is dry, apply a wash of burnt sienna and cobalt blue over the beach.*

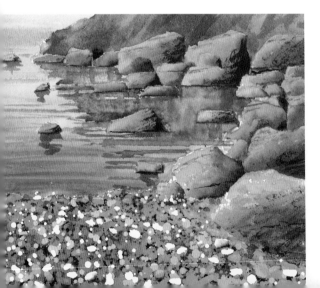

◀ **3** *Spatter a third layer of masking fluid on the beach. Define the rocks by painting on dark shadows using wet into wet and drybrush techniques. Add a few cracks, all dipping in the same direction. Add another wash to the backdrop. Work the reflection wet into wet, streaking the colors down the paper as you add them. Brush reflections under the rocks in blue water wet on dry. Add another brown wash, perhaps of light red and phthalo green, over the shingle. When dry, brush a few darks over the stones to create shadows between them. When this is dry, remove the masking fluid.*

Colors

*phthalo blue*  *indigo*  *burnt sienna*  *cobalt blue*  *cadmium orange*  *phthalo green*  *cadmium lemon*

# Underwater rocks

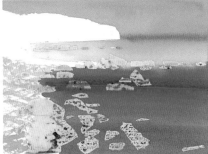

◀ **1** *Mask the rock shapes. Wet the paper, leaving cliffs and shore on the left. Use phthalo blue to paint the sky and sea, darkened below the rocks with indigo, and plenty of burnt sienna in the foreground. While still wet, brush a blue gray mix of cobalt blue and burnt sienna along the horizon line. The shore rocks to the left are crisscrossed with a mix of burnt sienna and cadmium orange.*

▶ **2** *Streak the blue gray mix wet into wet across the sea above the rocks. Add vertical streaks below the cliffs to imply reflections in calm water. While still wet, streak with a mix of phthalo green and cadmium lemon. Paint the tops of the cliffs in a light brown-green followed by a darker green for the clifftop grass. Crisscross more color onto the shore rocks to build up texture. Brush different colors on and around rocks. Add dark shadows under the foreground rocks in the water, then lift the underwater rocks with a damp brush and dab with tissue paper.*

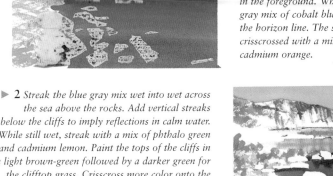

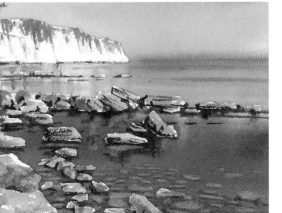

◀ **3** *Carefully add burnt sienna to underwater rocks to tone them back into the painting. When dry, brush the same dark detail between them. Dry brush the surface rocks with burnt sienna, cadmium lemon, and phthalo green. Mix shadow colors by adding cobalt blue to these and painting them on the sides. Deep darks are brushed in to define the rocks. Green is roughly brushed in above the rocks for the mass of foliage that helps define their shapes.*

# Sea and sky

## Storm at sea

Colors

Naples yellow
quinacridone red
phthalo green
phthalo blue
titanium white
indigo

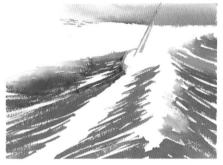

◀ **1** *Mask the edge of the boat, the mast, sail, and some streaks in the waves. Then wet the sky, and brush in streaks of Naples yellow, quinacridone red, and a little phthalo green, letting them mix on the paper. Apply a layer of gum arabic below the sky to produce the soft edge with the sea. Loosely drag directional brush strokes of mixed phthalo blue, phthalo green, and indigo across the sea, letting flecks of white paper show. Brush clear water and gum arabic into the white foam areas and let the color bleed to form soft edges. Leave to dry.*

▶ **2** *Drag further streaks of phthalo green, phthalo blue, and indigo across the sea. Wet the white surf, and add a little gum arabic. While this is still wet, paint a mix of dark phthalo blue and indigo into the shadow side of the waves, letting it bleed into the surf. Add phthalo green to the lighter areas of the sea. Leave to dry.*

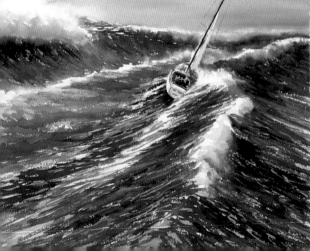

◀ **3** *Drag further streaks with the same colors over the sea, building up the pattern of the waves. When this has dried, paint lines of titanium white following the direction of the waves. Remove all masking fluid, and model the lighter areas of the boat with a mix of Naples yellow and indigo, leaving the hull edges white. Use indigo for the dark detail on the boat. Paint the crew in quinacridone red.*

# Lighthouse

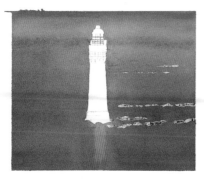

◀ **1** *Mask the railings and window bars at the top of the lighthouse and the foam trails around the rocks. Wet the paper, leaving the lighthouse dry. Brush quinacridone red along the horizon, cobalt blue into the sky, and burnt sienna below the horizon. While this is still wet, wash phthalo blue over the whole painting, making the tone darker in the foreground water and avoiding the lighthouse reflection. Leave to dry.*

▶ **2** *Brush phthalo blue onto the sea, avoiding the lighthouse reflection except for a few ripples across it. Wet the lighthouse, and add a mix of cobalt blue and burnt sienna to the left side, letting it spread. Darken it by adding a little indigo. Paint the top of the lighthouse in cadmium scarlet, wet into wet.*

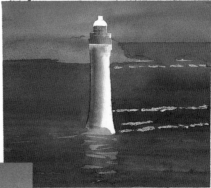

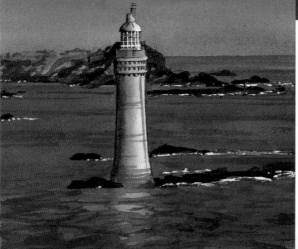

◀ **3** *Paint the distant headland in a mix of burnt sienna and cobalt blue. When this is dry, pick out some shadows in a darker version of the same mix. Paint the rocks in the sea in Payne's gray. Pick out the detail on the main body of the lighthouse in a mix of cobalt blue and burnt sienna, then paint the dark window details in Payne's gray. Dry brush phthalo blue across the foreground sea. Remove the masking.*

# Sea and sky

**Colors**

quinacridone red

yellow ochre

phthalo blue

burnt sienna

cobalt blue

indigo

phthalo green

## Foaming surf

◀ **1** *Wet the sky. Paint a strip of yellow ochre along the top of the paper, quinacridone red along the horizon, and phthalo blue below. Drag ripples of phthalo blue down from the damp part of the paper onto the dry part, spacing the strokes farther apart and changing the color to burnt sienna as you work toward the foreground.*

▶ **2** *Rewet the sky. Paint phthalo blue along the top of the paper and cobalt blue along the horizon. Lift out the clouds with tissue paper, and leave to dry. While working downward, paint the sea in horizontal strokes, leaving some white paper. Start with a mix of phthalo blue and indigo, change to phthalo green, then phthalo blue, and finally use burnt sienna. Dry brush cobalt blue into the foam. Paint the headland in yellow ochre and the foreground rocks in a mix of burnt sienna and cobalt blue.*

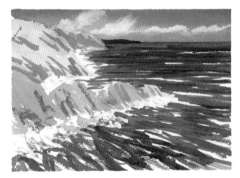

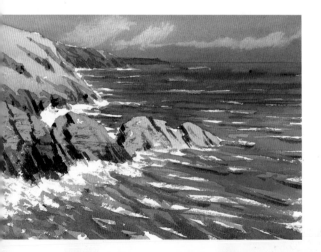

◀ **3** *Paint the headland with a mix of cobalt blue and burnt sienna, varying the tones. Use indigo to deepen the shadows on the rocks and the dark areas under the waves. The white of the paper is used to convey the foam splashing on the rocks.*

Colors

cobalt blue
burnt sienna
alizarin crimson

# Moonlight on water

◀ **1** *Mask the light edges of the clouds. Paint the sky and land in a pale gray mixed from cobalt blue, burnt sienna, and alizarin crimson. Leave to dry.*

▶ **2** *Paint the sky with a blue-biased mix of cobalt blue, burnt sienna, and alizarin crimson. While this is still damp, use tissue paper to lift out streaks of high clouds. Leave to dry. Paint the sea in the same mix, leaving a broad streak of white paper down the center.*

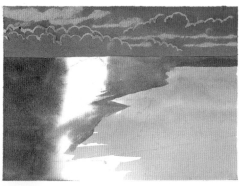

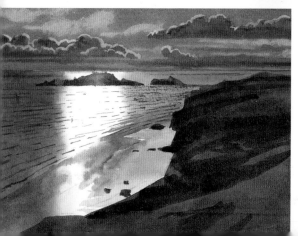

◀ **3** *Rewet the sky, and paint the undersides of the cloud banks in a dark mix of cobalt blue, burnt sienna, and alizarin crimson. Paint the foreground hills in a dark brown mixed from burnt sienna and cobalt blue. When this is dry, paint the shadows on the land, the islets, and the ripples on the sea in a dark mix of cobalt blue, burnt sienna, and alizarin crimson.*

# CREDITS

ARTIST Joe Francis Dowden
EDITOR Kate Tuckett
ART EDITOR AND DESIGNER Jill Mumford
ASSISTANT ART DIRECTOR Penny Cobb
COPY EDITOR Sarah Hoggett
PROOFREADER Pamela Ellis

ART DIRECTOR Moira Clinch
PUBLISHER Piers Spence

Manufactured by Universal Graphics (Pte) Ltd., Singapore
Printed by Leefung-Asco Printers, China

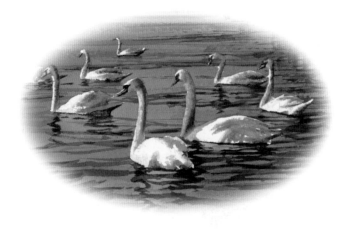